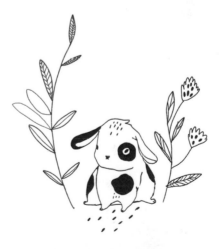

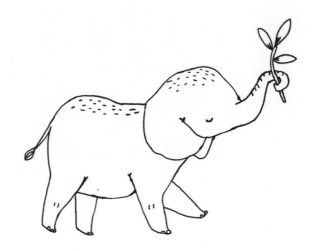

MAJA SÄFSTRÖM

amazing
FACTS ABOUT

**BABY
ANIMALS**

an illustrated
COMPENDIUM

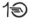

TEN SPEED PRESS
CALIFORNIA | NEW YORK

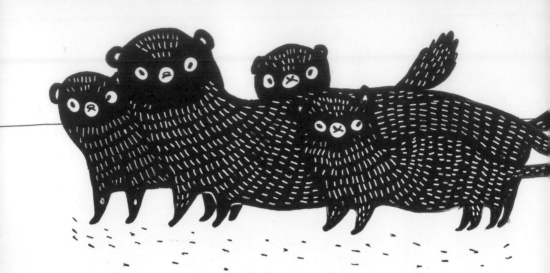

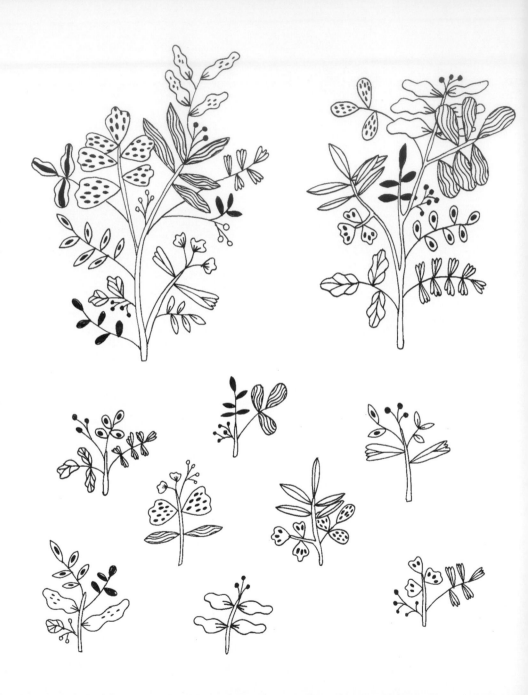

DEAR READER,

THE ANIMAL WORLD IS FULL OF
ALL DIFFERENT KINDS OF BABIES,
PARENTS, AND FAMILIES.

IN THIS BOOK I HAVE
PRESENTED A FEW OF THEM!

SOME BABIES LIVE WITH THEIR
FAMILIES FOR A LONG TIME;
OTHERS HAVE TO GROW UP VERY FAST.

LIKE US, ALL ANIMALS WANT
THEIR BABIES TO HAVE THE OPPORTUNITY
TO GROW UP HEALTHY AND STRONG.

I HOPE THAT YOU WILL
ENJOY THE BOOK, LEARN
SOMETHING NEW, AND BE REMINDED
OF THE AMAZING DIVERSITY
OF THE ANIMAL WORLD.

DOLPHINS
HAVE THEIR OWN SPECIAL SOUNDS.
JUST LIKE WE HAVE NAMES!

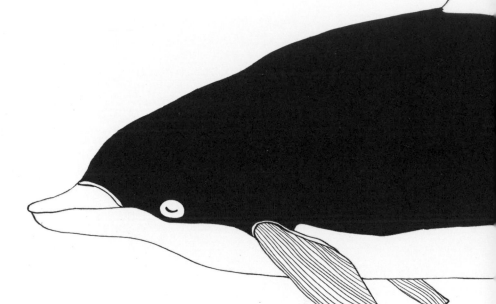

A PREGNANT DOLPHIN SINGS
TO HER BABY WHEN IT'S IN HER BELLY,

SO THAT IT WILL RECOGNIZE
HER VOICE WHEN IT'S BORN.

BATS
OFTEN GIVE BIRTH
WHILE HANGING
UPSIDE DOWN!

THEN THE UMBILICAL CORD
FUNCTIONS AS A LIFELINE
THAT THE BABY CAN USE
TO CLIMB UP TO ITS MOTHER
IF SHE DOESN'T MANAGE TO
CATCH IT WITH HER WINGS.

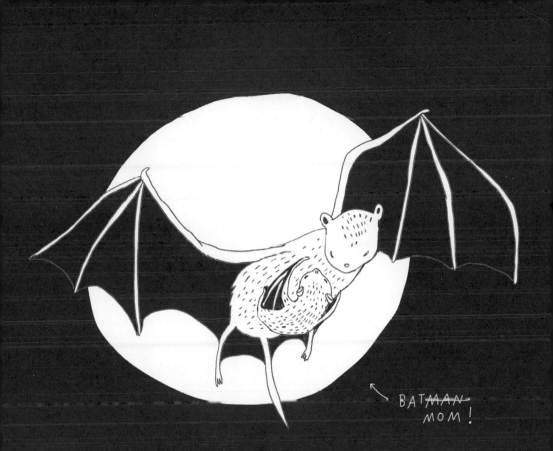

BATMAN MOM!

IF A BAT MOM NEEDS
TO MOVE HER BABY,
SHE LETS IT CLING
TO HER BELLY
WHILE SHE FLIES.

11.

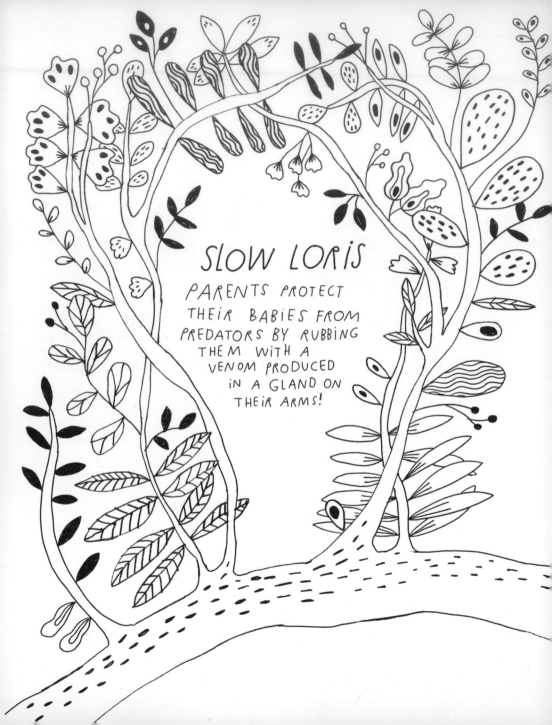

SLOW LORIS

PARENTS PROTECT THEIR BABIES FROM PREDATORS BY RUBBING THEM WITH A VENOM PRODUCED IN A GLAND ON THEIR ARMS!

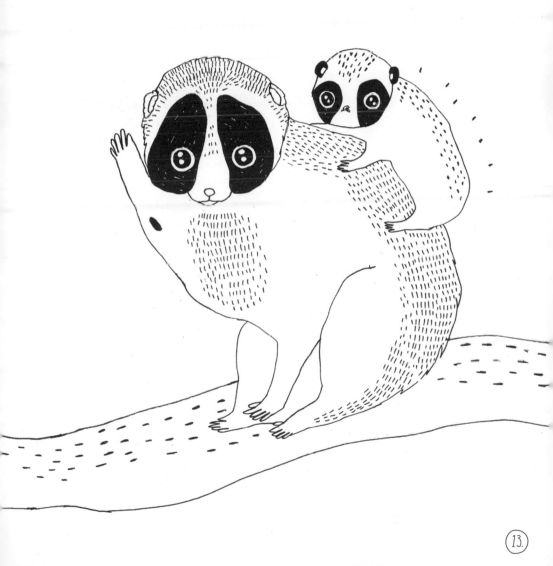

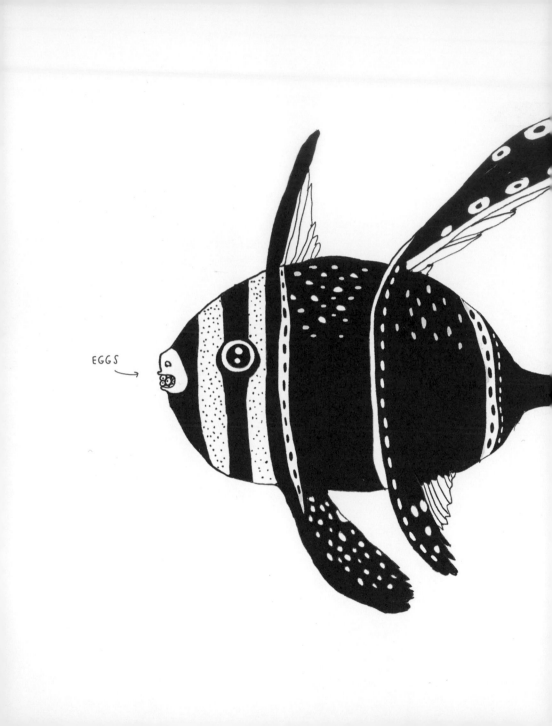

EGGS

WHEN
BANGGAI
CARDINAL FiSH
MATE, THE FEMALE
PUTS HER EGGS iN
THE MOUTH OF THE
FUTURE FATHER.

HE THEN CAREFULLY
INCUBATES THEM THERE
UNTiL THEY HATCH ABOUT
A MONTH LATER

THE FATHER
DOES NOT
EAT ANYTHING
DURING
THiS TiME!

BUT
THE FEMALE
STAYS CLOSE
← AND LOOKS
AFTER HIM.

THE BABiES THEN
STAY iN HiS MOUTH
FOR A FEW MORE WEEKS
UNTIL iT'S TIME
TO MOVE AWAY
FROM HOME.

SQUIRRELS

HAVE BABY TEETH WHEN
THEY ARE SMALL, JUST
LIKE HUMAN CHILDREN.

(THIS IS ACTUALLY TRUE FOR
ALMOST ALL MAMMALS!)

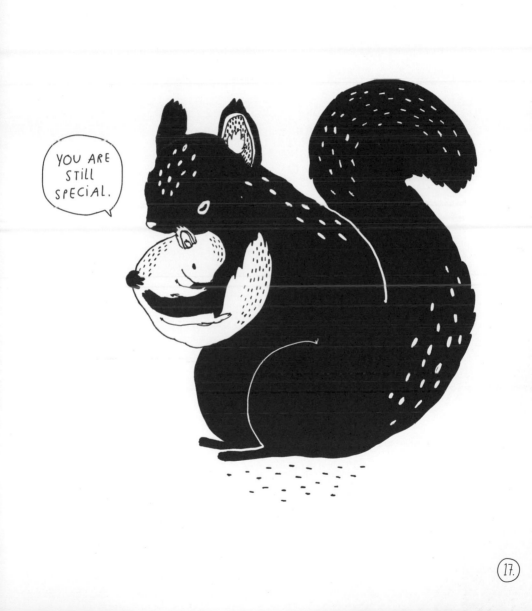

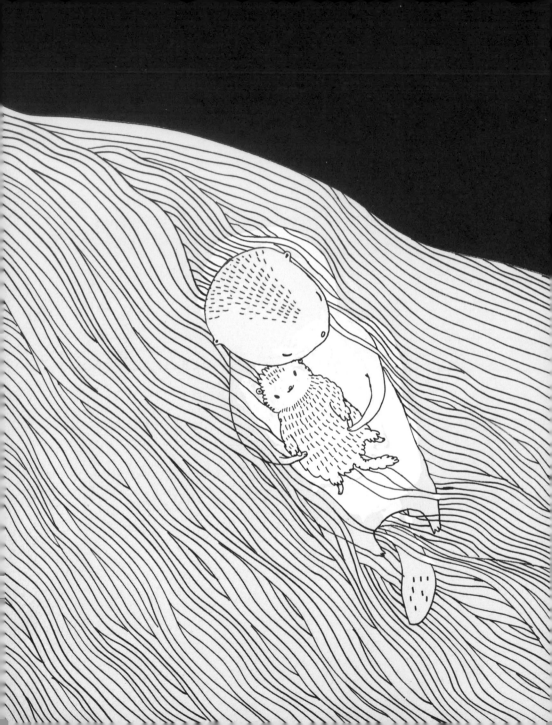

SEA OTTERS

CANNOT SWIM
WHEN THEY ARE BORN,
SO FOR THE FIRST MONTHS
OF THEIR LIVES, THEY
STAY ON THEIR MOTHER'S
BELLY IN THE WATER.

BUT THE BABY HAS
EXTRA-THICK FUR THAT
THE MOTHER CAN GROOM
TO BE SO **FLUFFY**

THAT SHE CAN
LEAVE IT FLOATING
FOR A COUPLE OF MINUTES
WHILE SHE DIVES DOWN
IN THE WATER
TO GET FOOD.

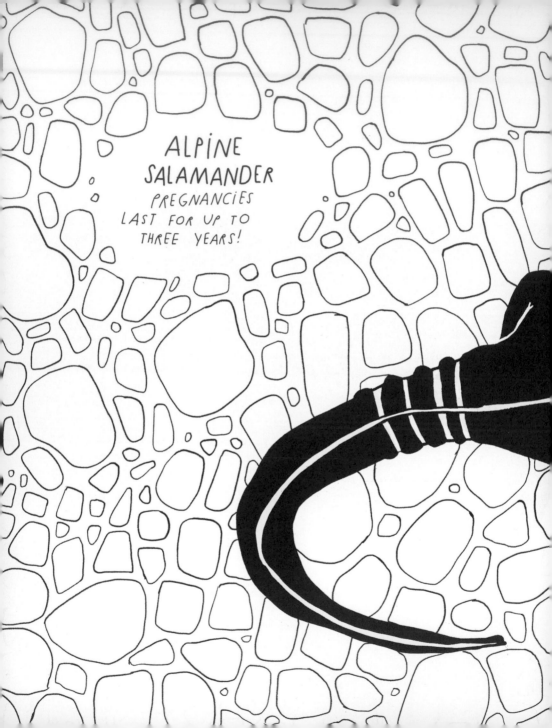

ALPINE
SALAMANDER
PREGNANCIES
LAST FOR UP TO
THREE YEARS!

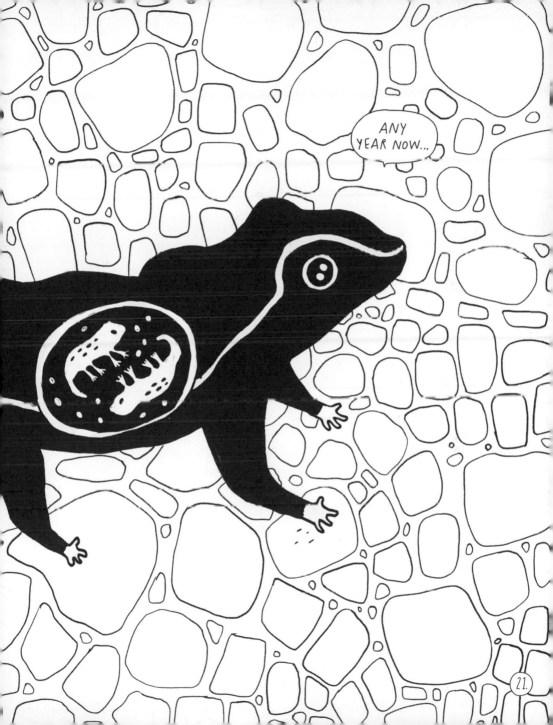

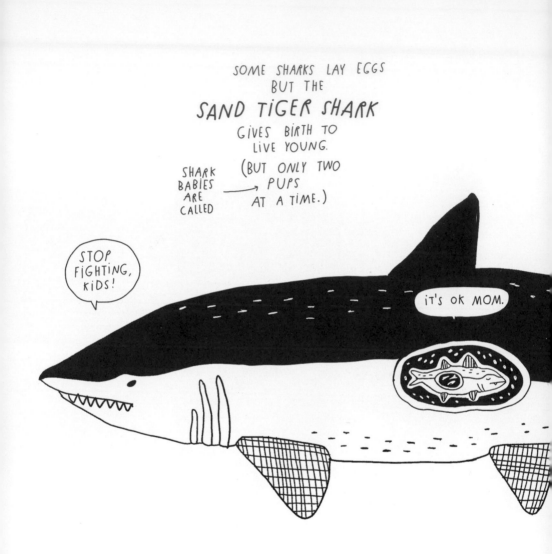

THE BROTHERS AND
SISTERS EAT EACH OTHER
IN THE WOMB...

... UNTIL JUST
THE STRONGEST ONE
IS LEFT.

WE SOLVED IT!

THE REASON TWO
PUPS ARE BORN AND
NOT JUST ONE IS
BECAUSE SAND TIGER SHARKS
HAVE TWO SEPARATE
UTERI.

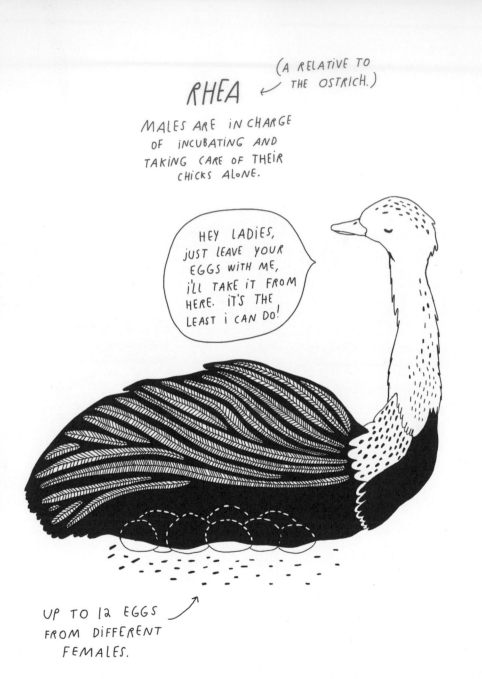

SISTERS AND
BROTHERS
FROM ANOTHER
MOTHER.

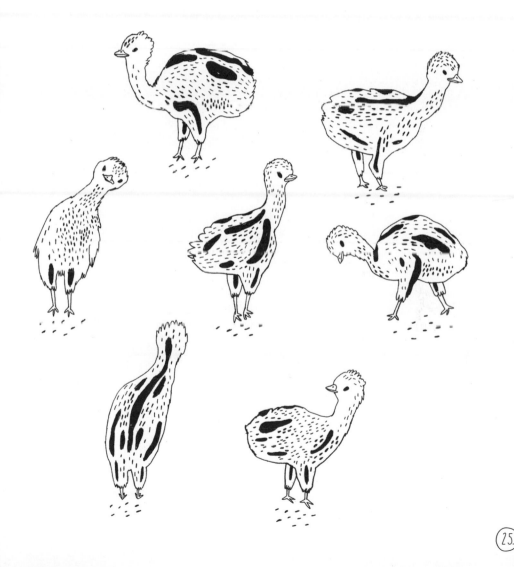

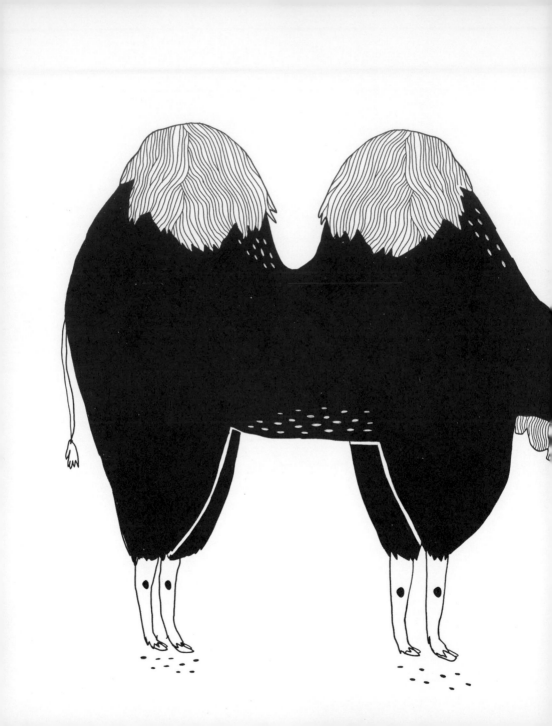

CAMEL BABIES
ARE BORN
WITHOUT HUMPS.

NO
HUMP
↓

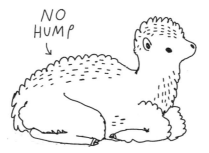

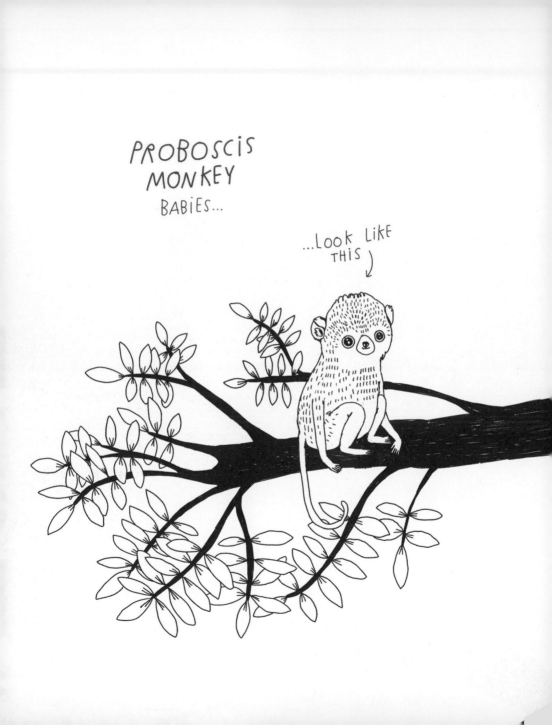

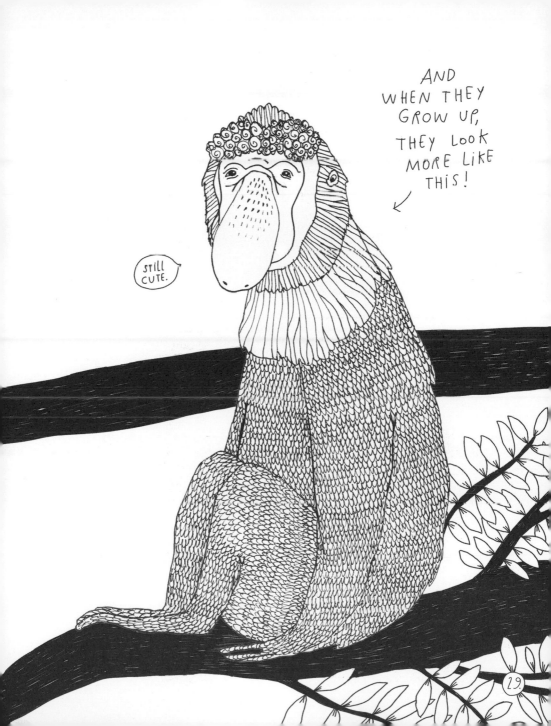

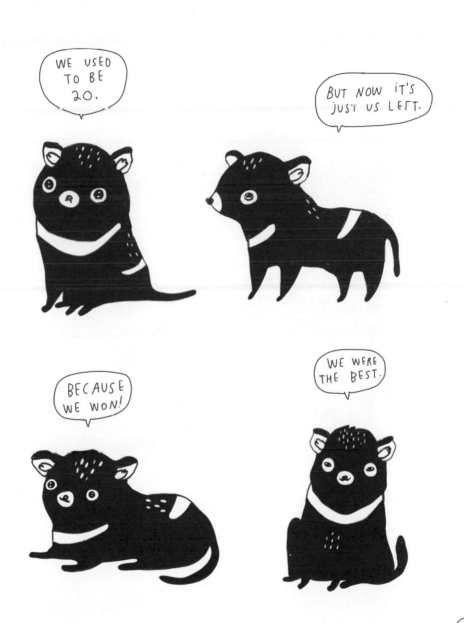

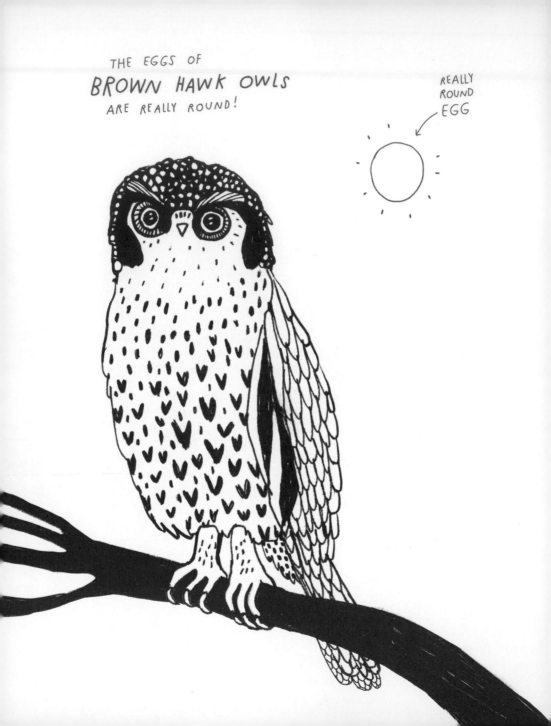

AND
THEIR BABIES
ARE PRETTY
ROUND TOO.

NILE CROCODILES

OFTEN DIG THEIR EGGS DOWN IN SAND DUNES AND GUARD THEM THERE ← (FOR ABOUT THREE MONTHS) UNTIL THEY HATCH.

MEANWHILE, THE TEMPERATURE AROUND THE EGGS DETERMINES WHAT GENDER THE BABIES WILL BE.

WARM -----> GIRLS
MEDIUM -----> BOYS
COLD -----> GIRLS

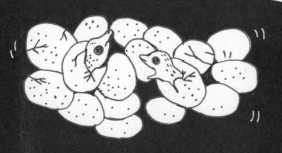

CROCODILE BABIES MAKE SOUNDS FROM
INSIDE THE EGGS TO SIGNAL TO
THEIR PARENTS THAT THEY ARE
READY TO BE DUG UP AND HATCH!

SOMETIMES THE PARENTS
EVEN HELP CRACK THE
BABIES OUT OF THEIR
EGGS BY GENTLY CRUSHING
THE EGGS IN THEIR MOUTHS.

WHEN iT iS TIME TO NEST,

YELLOW-BiLLED HORNBiLL COUPLES

SEEK OUT A HOLE iN A TREE THAT
THEY PREPARE TOGETHER.

WHEN EVERYTHING iS READY, THE FEMALE
MOVES iN AND CLOSES THE
ENTRANCE WiTH HER FECES. ← FANCY WORD
FOR "POOP:"

SHE THEN LAYS HER EGGS
AND LOSES MOST OF HER FEATHERS.

THE MALE THEN
NEEDS TO FEED HER THROUGH A LiTTLE
OPENiNG iN THE (POOP) WALL.

THREE WEEKS AFTER THE CHiCKS HAVE
HATCHED, THE MOTHER HAS GROWN NEW
FEATHERS AND BREAKS OUT OF THE NEST.

THEN THE CHiCKS REBUiLD THE WALL
AND STAY FOR SiX MORE
WEEKS UNTiL iT iS TIME
FOR THEM TO LEAVE HOME!

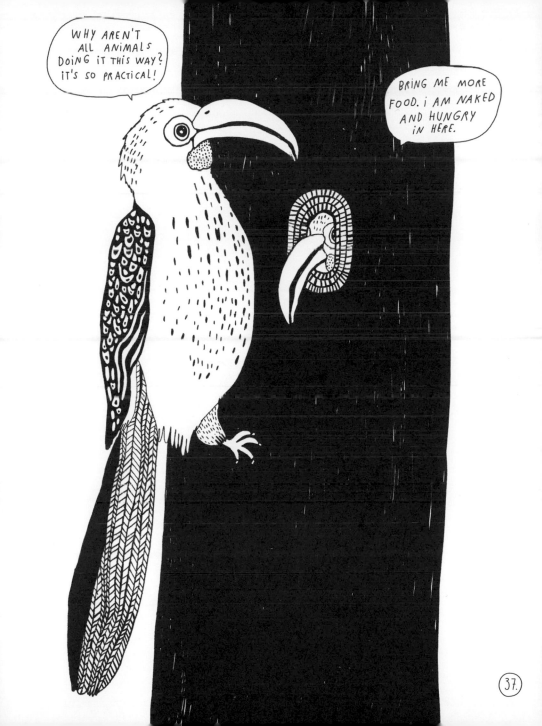

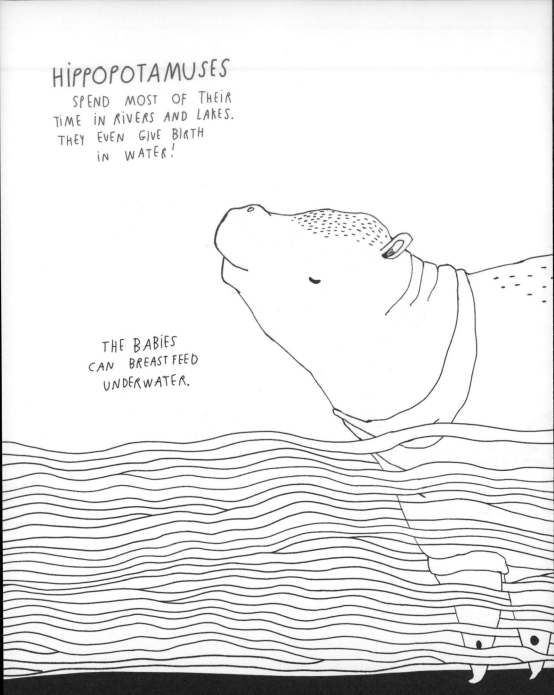

HIPPOPOTAMUSES

SPEND MOST OF THEIR
TIME IN RIVERS AND LAKES.
THEY EVEN GIVE BIRTH
IN WATER!

THE BABIES
CAN BREAST FEED
UNDERWATER.

ALTHOUGH THEY
LOVE WATER,
HIPPOS ARE NOT VERY
GOOD SWIMMERS.

IF THE WATER IS TOO
DEEP FOR THE BABIES,
THEY CAN CLIMB UP ON
THEIR PARENTS' BACKS
TO REST!

HERMIT CRABS

HAVE SOFT AND VULNERABLE
BODIES SO THEY MUST
CONSTANTLY SEEK NEW
(SOMEONE ELSE'S OLD) SHELLS
TO MOVE INTO
AS THEY GROW.

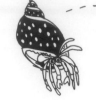

THEY PREFER
OLD SNAIL SHELLS,
BUT IF THERE ARE
NO SHELLS TO BE
FOUND, THEY
WILL MOVE INTO
ANYTHING WITH A
GOOD SHAPE, LIKE
A PIECE OF WOOD
OR STONE.

SOFT AND
VULNERABLE
BODY

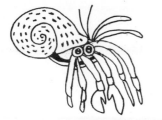

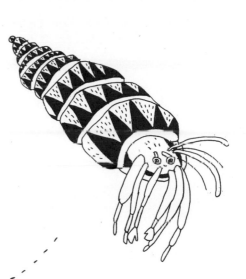

IF A HERMIT CRAB
FINDS AN EMPTY SHELL
THAT IS TOO BIG, IT
SITS DOWN NEXT TO
IT AND WAITS UNTIL
A BIGGER FRIEND
COMES ALONG.

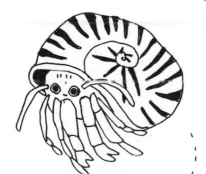

SOMETIMES MANY
CRABS GATHER UNTIL
ONE THAT FITS THE NEW
SHELL ARRIVES.
THEN THEY LINE UP
FROM BIG TO SMALL
AND SWAP SHELLS
UNTIL EVERYONE
GETS A NEW ONE!

WILD BOARS OFTEN WALK AFTER EACH OTHER IN A LINE.

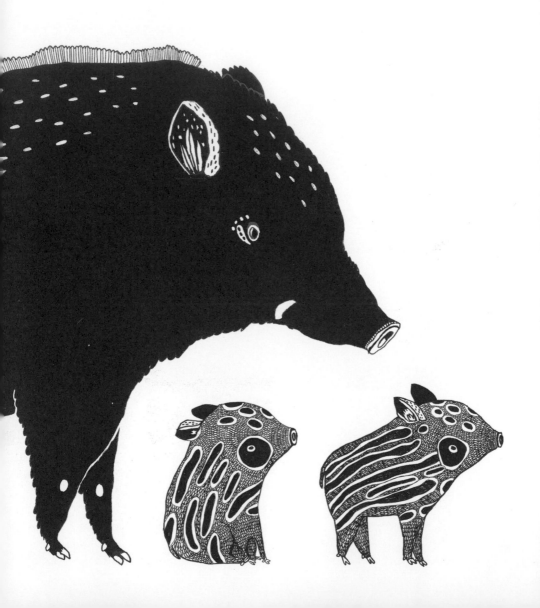

AND THEIR
BABIES LOOK
LIKE THIS!

(SORT OF.)

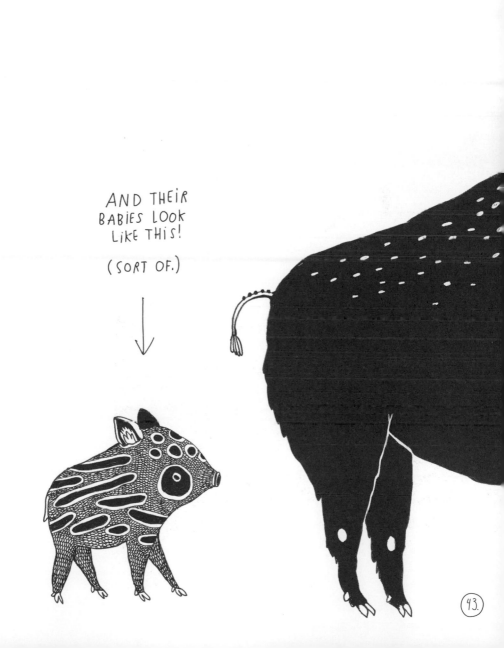

A HONEYBEE COMMUNITY CONSISTS OF:

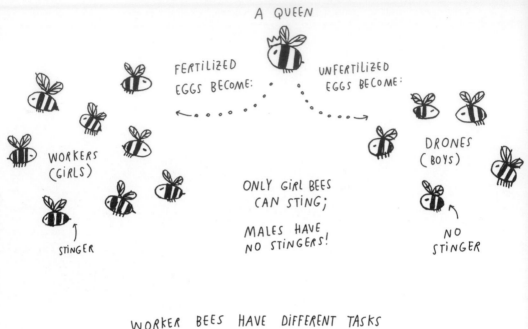

A QUEEN

FERTILIZED EGGS BECOME:

UNFERTILIZED EGGS BECOME:

WORKERS (GIRLS)

DRONES (BOYS)

STINGER

ONLY GIRL BEES CAN STING;

MALES HAVE NO STINGERS!

NO STINGER

WORKER BEES HAVE DIFFERENT TASKS DEPENDING ON THEIR AGE. SOMETHING LIKE THIS:

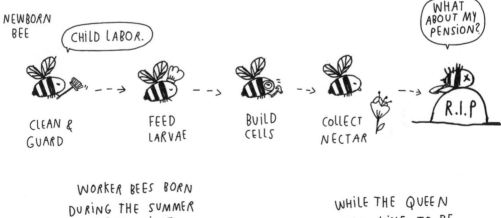

NEWBORN BEE

CHILD LABOR.

CLEAN & GUARD

FEED LARVAE

BUILD CELLS

COLLECT NECTAR

WHAT ABOUT MY PENSION?

R.I.P

WORKER BEES BORN DURING THE SUMMER LIVE FOR JUST A FEW WEEKS.

WHILE THE QUEEN CAN LIVE TO BE FIVE YEARS OLD!

FOR A NEW QUEEN TO DEVELOP, A FERTILIZED EGG MUST BE LAID IN AN EXTRA LARGE QUEEN CELL.

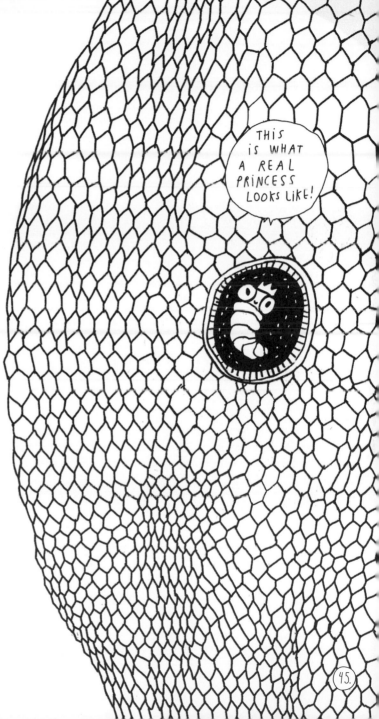

THE LARVA IS THEN EXCLUSIVELY FED WITH A VERY NUTRITIOUS "ROYAL JELLY."

(ORDINARY LARVAE GET TO EAT MOSTLY POLLEN AND HONEY.)

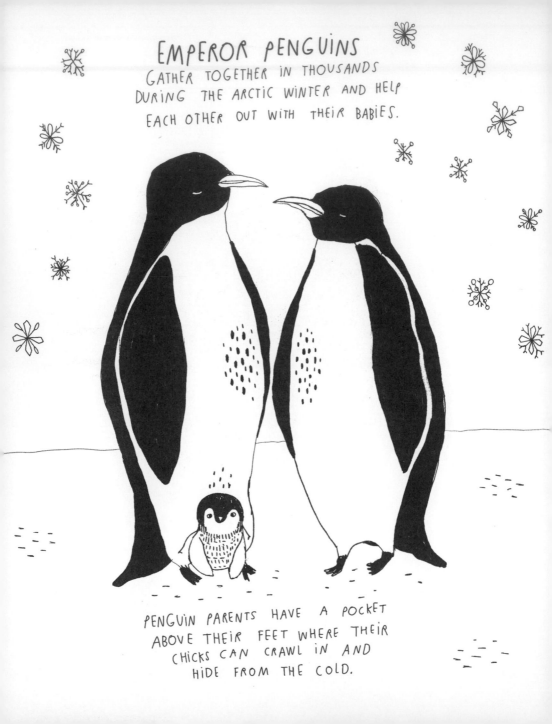

EMPEROR PENGUINS

GATHER TOGETHER IN THOUSANDS
DURING THE ARCTIC WINTER AND HELP
EACH OTHER OUT WITH THEIR BABIES.

PENGUIN PARENTS HAVE A POCKET
ABOVE THEIR FEET WHERE THEIR
CHICKS CAN CRAWL IN AND
HIDE FROM THE COLD.

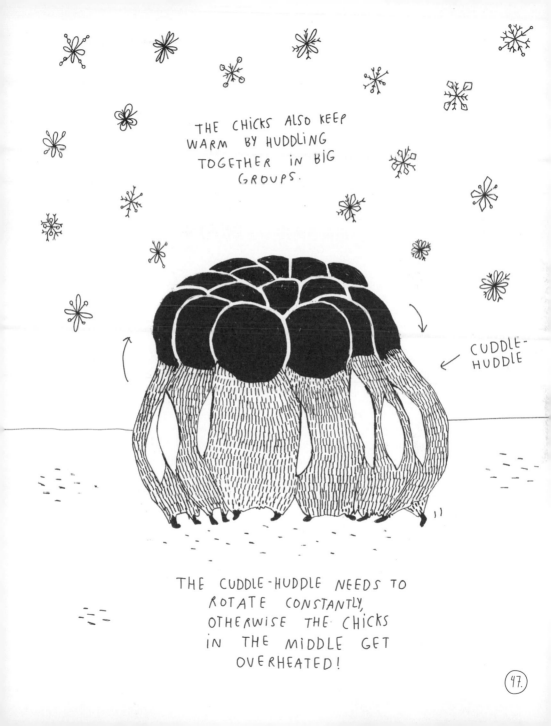

THE CHICKS ALSO KEEP WARM BY HUDDLING TOGETHER IN BIG GROUPS.

CUDDLE-HUDDLE

THE CUDDLE-HUDDLE NEEDS TO ROTATE CONSTANTLY, OTHERWISE THE CHICKS IN THE MIDDLE GET OVERHEATED!

ELEPHANT SISTERS
OFTEN STAY TOGETHER
THEIR WHOLE LIVES

AND TAKE CARE OF THEIR
BABIES (AND GRANDCHILDREN)
TOGETHER!

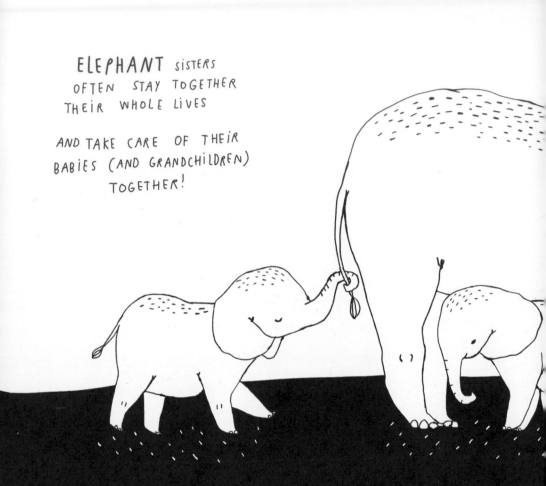

INSTEAD OF HOLDING HANDS,
ELEPHANTS HOLD EACH OTHER'S
TAILS (WITH THEIR TRUNKS).

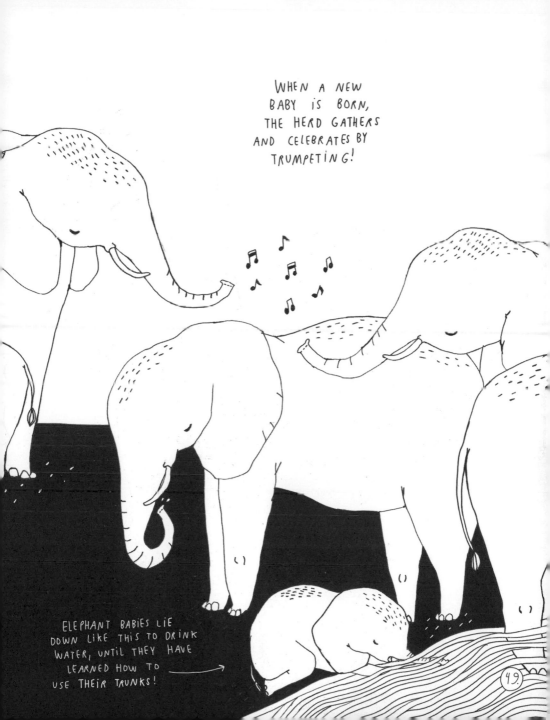

WHEN A NEW BABY IS BORN, THE HERD GATHERS AND CELEBRATES BY TRUMPETING!

ELEPHANT BABIES LIE DOWN LIKE THIS TO DRINK WATER, UNTIL THEY HAVE LEARNED HOW TO USE THEIR TRUNKS! →

THE **OCEAN SUNFISH**
LAYS <u>HUNDREDS OF MILLIONS</u>
OF EGGS AT A TIME.

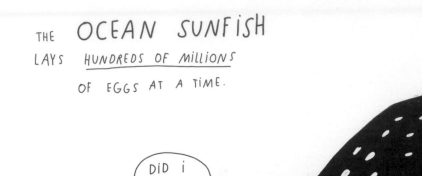

DID i
OVERDO
iT AGAIN?

A SUNFISH CAN
GROW UP TO
13 FEET (4 METERS),

BUT THEIR BABIES
ARE TiNY
AND TRANSPARENT.

BABY OCEAN
SUNFISH

ACTUAL
SIZE

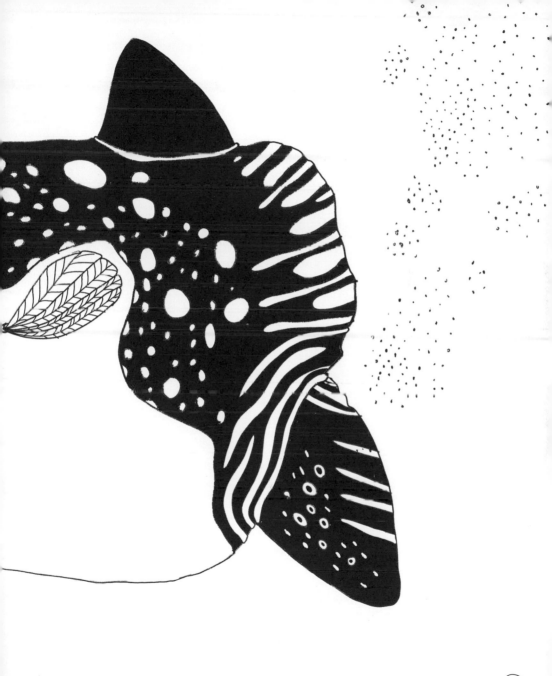

CUCKOO BIRDS

DON'T BRING UP THEIR OWN
CHICKS. INSTEAD, FEMALE CUCKOOS
LAY THEIR EGGS IN THE
NESTS OF OTHER BIRDS.

THE CUCKOO EGG HAS ADAPTED
TO HATCH BEFORE THE OTHER
EGGS, AND WHEN IT DOES,
THE CUCKOO CHICK KICKS
OUT THE OTHER EGGS SO
THAT IT'S LEFT ALONE.

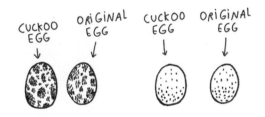

CUCKOO ORIGINAL CUCKOO ORIGINAL
EGG EGG EGG EGG

CUCKOOS HAVE
DEVELOPED EGGS
THAT LOOK JUST
LIKE THE EGGS OF
THEIR INVOLUNTARY
ADOPTIVE PARENTS.

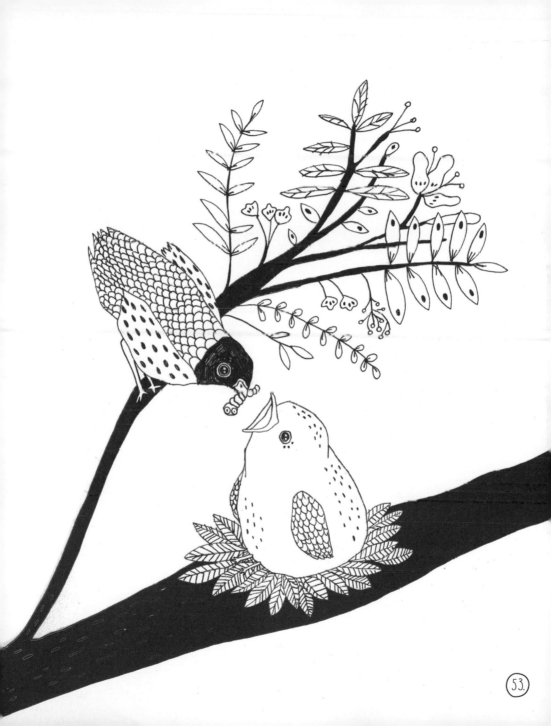

WHEN **SEAHORSES** HAVE BABIES, IT'S THE FATHERS WHO ARE PREGNANT.

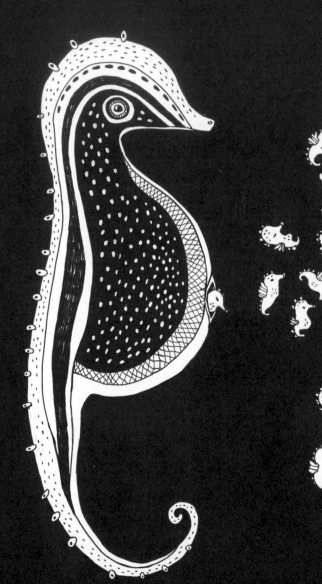

THE BABIES ARE
BORN DURING THE NIGHT...

...THOUSANDS
AT A TIME...

...AND THEY
HAVE TO CARE
FOR THEMSELVES
FROM THE MOMENT
THEY LEAVE THEIR
FATHER'S BELLY.

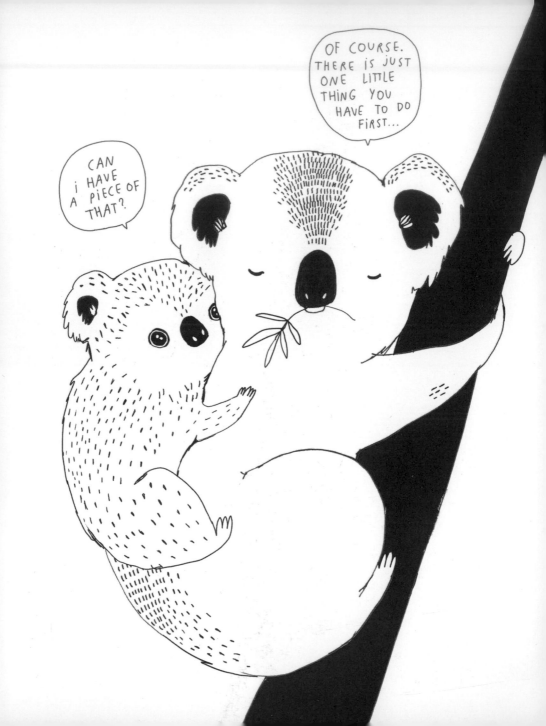

BEFORE A **KOALA** BABY CAN START EATING EUCALYPTUS LEAVES, ← THE ONLY THING ADULT KOALAS EAT... WHICH ARE VERY TOUGH TO DIGEST,

THE BABY FIRST HAS TO EAT ITS MOTHER'S

POOP

TO GET THE RIGHT GUT BACTERIA.

SOME **STINGRAYS**
GIVE BIRTH TO LIVE YOUNG.

(THEY KEEP THE EGGS <u>INSIDE</u>
THE BODY UNTIL THEY <u>HATCH</u>!)

NEWBORN
STINGRAYS LOOK
JUST LIKE SMALLER
VERSIONS OF THEIR
PARENTS AND CAN
EAT THE SAME THINGS AS THEM.
THEY EVEN HAVE VENOM
IN THEIR TAILS
FOR SELF-DEFENSE.

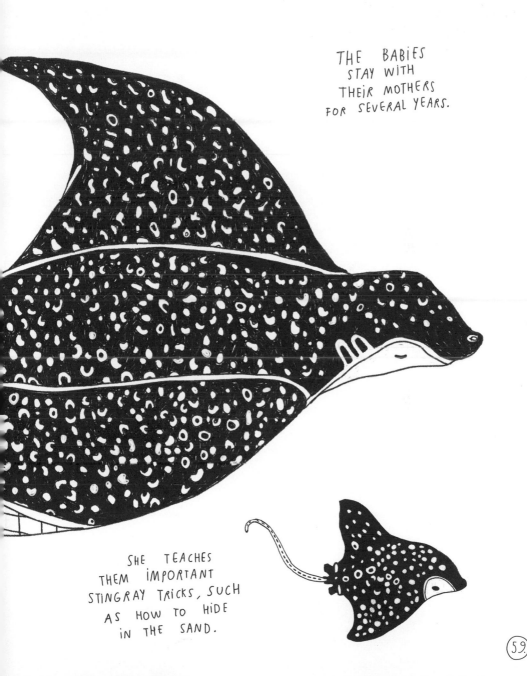

THE BABIES
STAY WITH
THEIR MOTHERS
FOR SEVERAL YEARS.

SHE TEACHES
THEM IMPORTANT
STINGRAY TRICKS, SUCH
AS HOW TO HIDE
IN THE SAND.

59.

MALEOS ARE ABOUT
THE SIZE OF ORDINARY CHICKENS,
BUT THEIR EGGS ARE MUCH
BIGGER THAN CHICKEN EGGS.

MALEO BIRD
EGG

CHICKEN
EGG

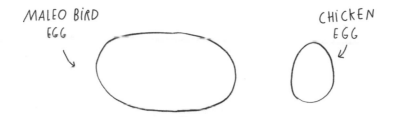

THE CHICKS
CAN FLY FROM
THE DAY THEY
ARE BORN.

THE CHICKS USE
THEIR FEET TO BREAK
OUT OF THE EGG.

THEN THEY NEED TO
DIG THEMSELVES UP
TO THE SURFACE.

↖ THIS
CAN TAKE
UP TO
TWO DAYS!

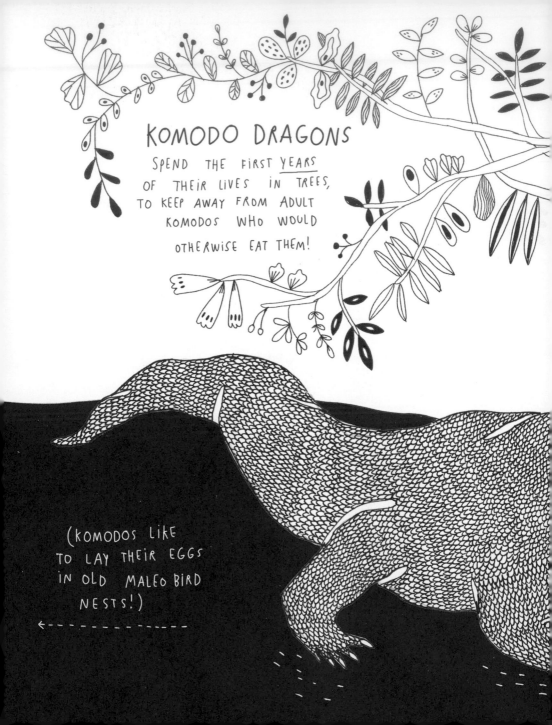

KOMODO DRAGONS

SPEND THE FIRST <u>YEARS</u> OF THEIR LIVES IN <u>TREES</u>, TO KEEP AWAY FROM ADULT KOMODOS WHO WOULD OTHERWISE EAT THEM!

(KOMODOS LIKE TO LAY THEIR EGGS IN OLD MALEO BIRD NESTS!)

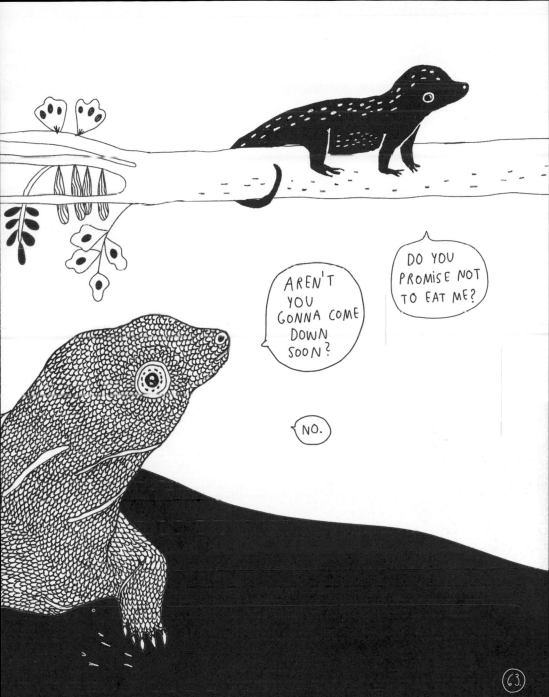

THIS IS HOW
LADYBUGS
GO FROM
BABIES TO LADIES:

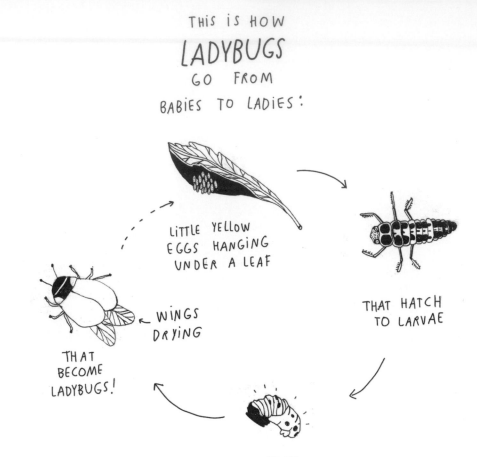

LITTLE YELLOW
EGGS HANGING
UNDER A LEAF

THAT HATCH
TO LARVAE

WINGS
DRYING

THAT
BECOME
LADYBUGS!

THAT
TURN INTO
PUPAE

RIGHT WHEN THE LADYBUG
COMES OUT OF THE
PUPA, IT'S MOIST AND PALE.
THE STRONG COLOR AND PATTERNS
APPEAR AFTER A FEW HOURS ONCE
THE SHELL HAS DRIED AND HARDENED.

THERE ARE THOUSANDS OF SPECIES
OF LADYBUGS, ALL WITH THEIR OWN SPECIAL PATTERNS.

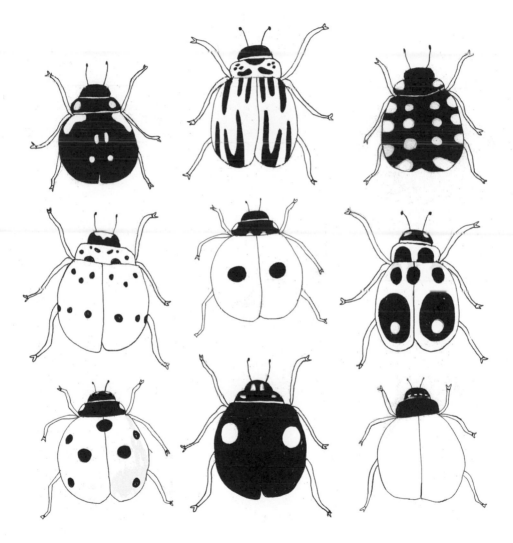

SOME DON'T HAVE SPOTS AT ALL!

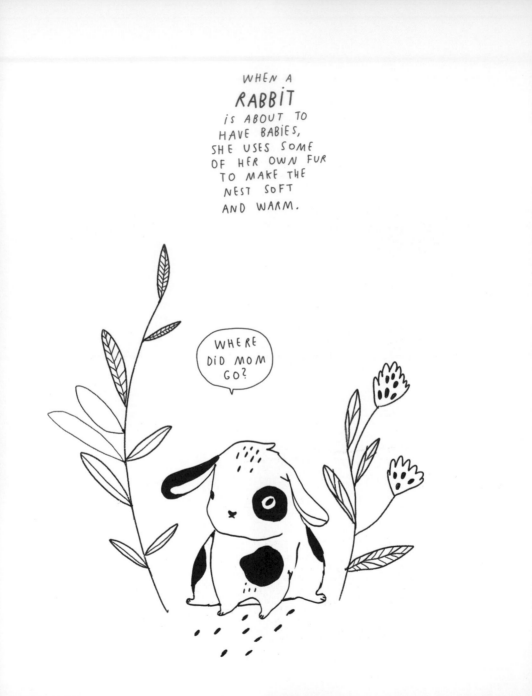

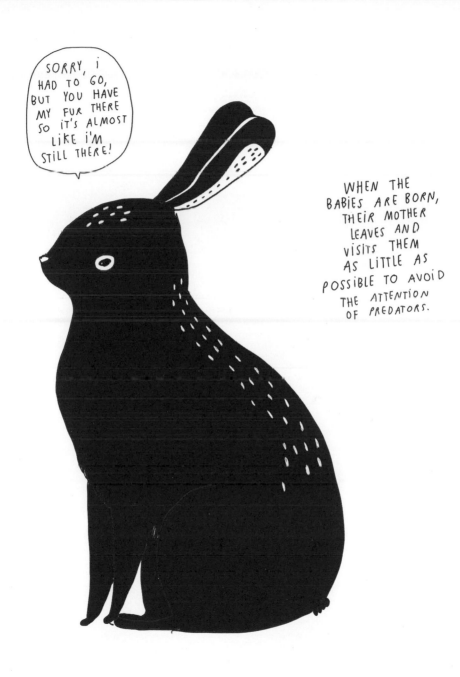

BEFORE A
WOLF SPIDER
LAYS EGGS, SHE SPINS A BAG
OF SILK THAT SHE CARRIES
THE EGGS IN UNTIL THEY HATCH!

EGG
BAG

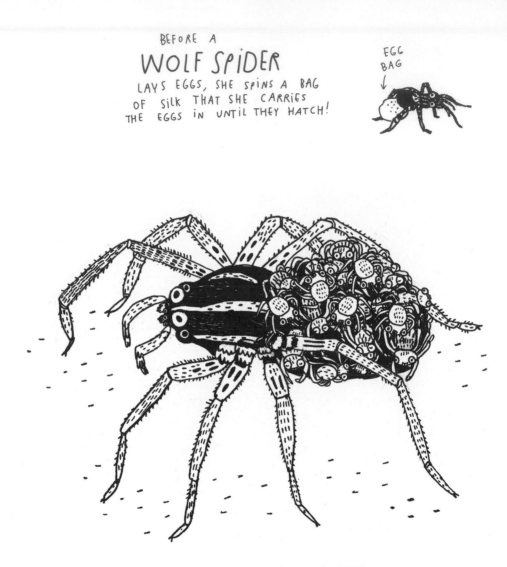

WHEN THE BABIES ARE BORN,
SHE CONTINUES TO CARRY THEM
ON HER BACK!

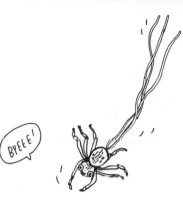

WHEN THE BABIES
ARE BIG ENOUGH TO
LEAVE, THEY CAN EITHER
JUST CLIMB DOWN
TO THE GROUND...

... OR SHOOT THEMSELVES
AWAY WITH A THREAD OF SILK
AND FLY AWAY IN THE WIND!

WHEN **CHEETAH** BABIES
ARE BIG ENOUGH TO
LEAVE THEIR MOTHER,
THEY FORM THEIR
OWN SIBLING GROUPS!

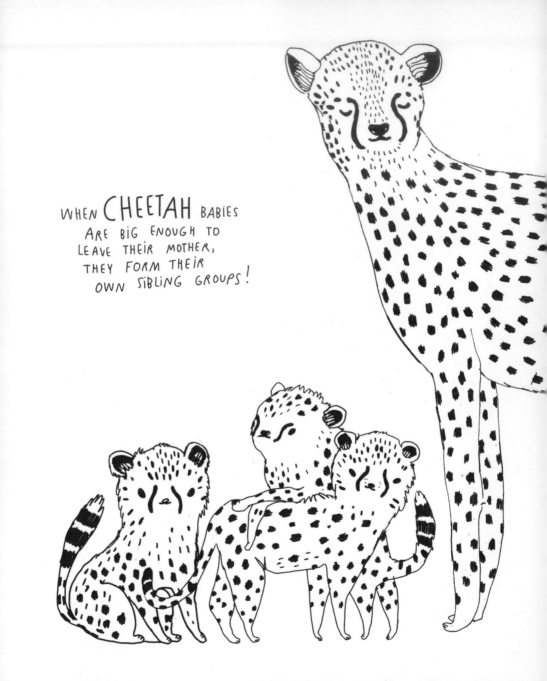

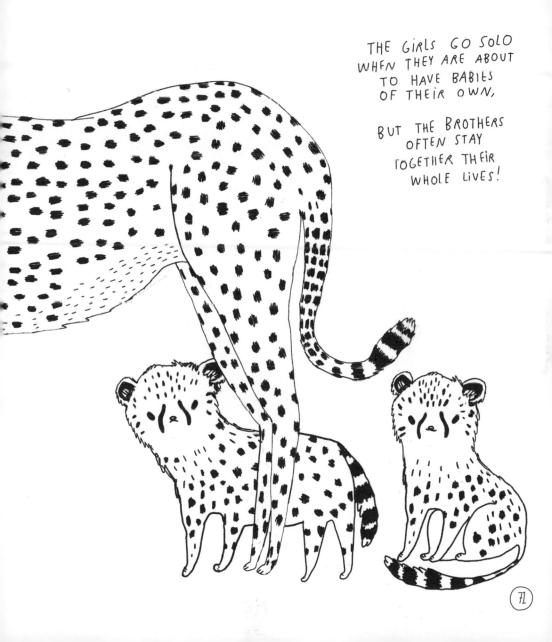

THE GIRLS GO SOLO
WHEN THEY ARE ABOUT
TO HAVE BABIES
OF THEIR OWN,

BUT THE BROTHERS
OFTEN STAY
TOGETHER THEIR
WHOLE LIVES!

WHEN A COUPLE OF
POISON DART FROGS
ARE ABOUT TO HAVE
BABIES, IT IS THE FATHER'S
TASK TO PEE ON THE
EGGS TO KEEP THEM MOIST.

WHEN THE TADPOLES HATCH,
THE PARENTS MOVE THEM
EACH TO ONE DROP
OF WATER.

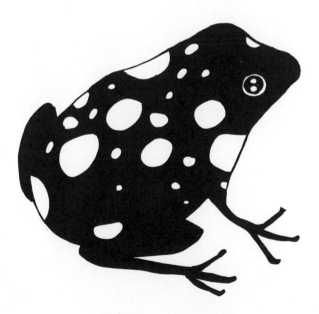

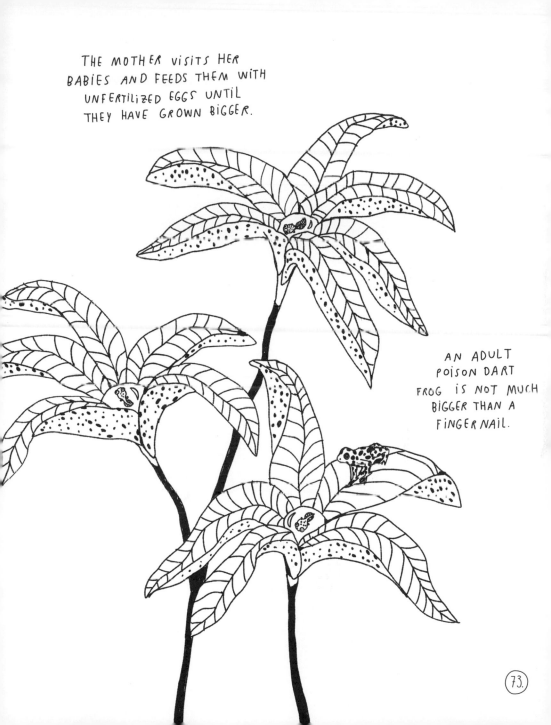

THE MOTHER VISITS HER
BABIES AND FEEDS THEM WITH
UNFERTILIZED EGGS UNTIL
THEY HAVE GROWN BIGGER.

AN ADULT
POISON DART
FROG IS NOT MUCH
BIGGER THAN A
FINGER NAIL.

73.

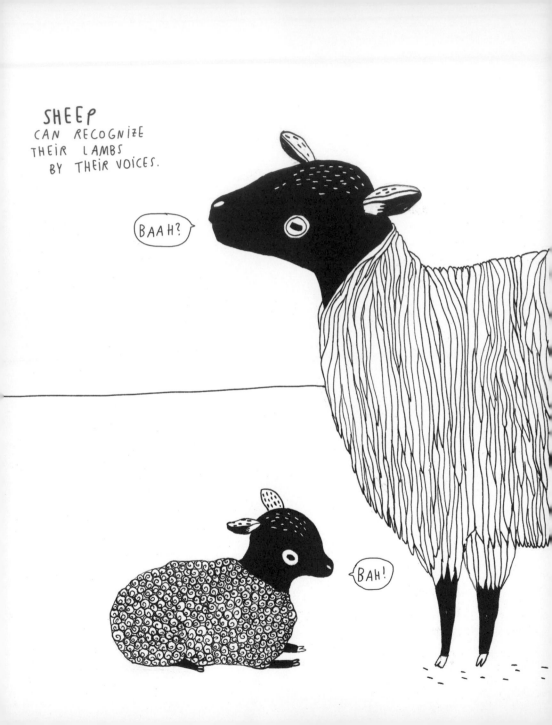

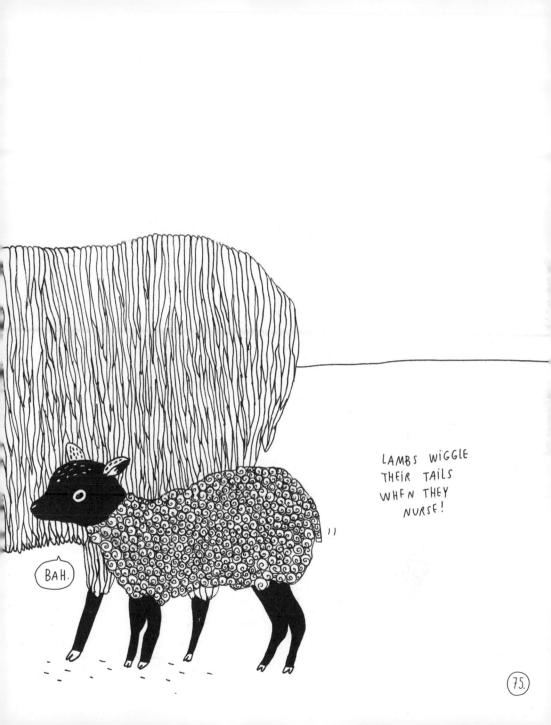

LAMBS WIGGLE
THEIR TAILS
WHEN THEY
NURSE!

BAH.

THE LIFE OF THE **EUROPEAN EEL**
HAS LONG REMAINED
A MYSTERY.

THEY ARE
BORN IN THE
SARGASSO SEA,
AND DRIFT WITH
THE GULF STREAM
TO EUROPE.

TRANSPARENT
EEL BABIES

3,000 MILES
FREE RIDE
(ONE-WAY TICKET)

THEIR BODIES GET
ROUNDER AS THEY
APPROACH THE COAST.

THEN THEY
ARE CALLED
"GLASS EELS".

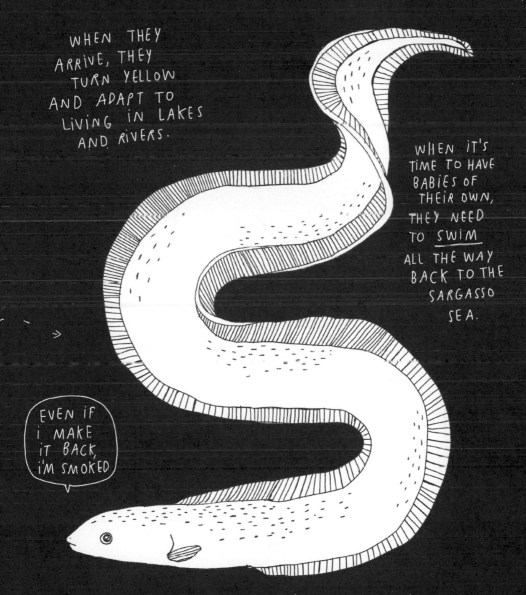

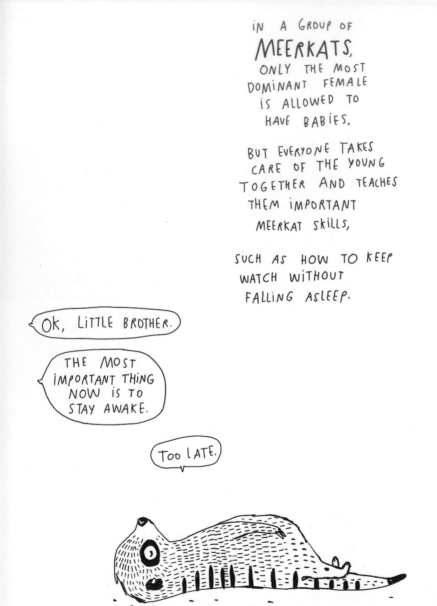

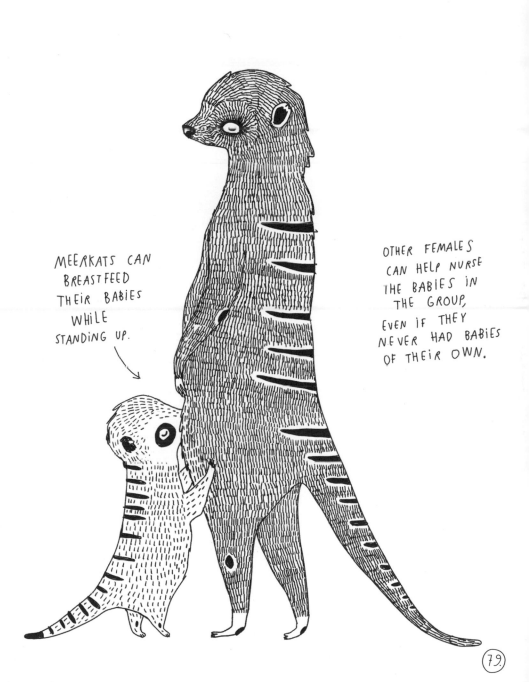

MEERKATS CAN
BREASTFEED
THEIR BABIES
WHILE
STANDING UP.

OTHER FEMALES
CAN HELP NURSE
THE BABIES IN
THE GROUP,
EVEN IF THEY
NEVER HAD BABIES
OF THEIR OWN.

79.

BABY **BISON**
ARE CALLED "RED DOGS"
BECAUSE OF THEIR
ORANGE-RED FUR.

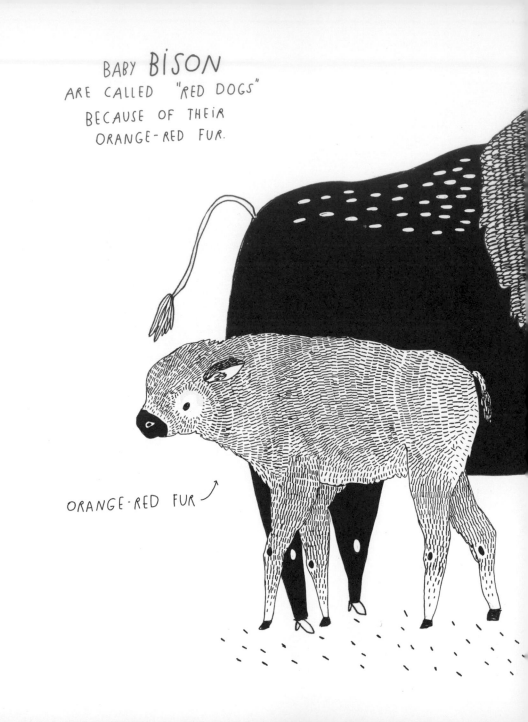

ORANGE-RED FUR ↗

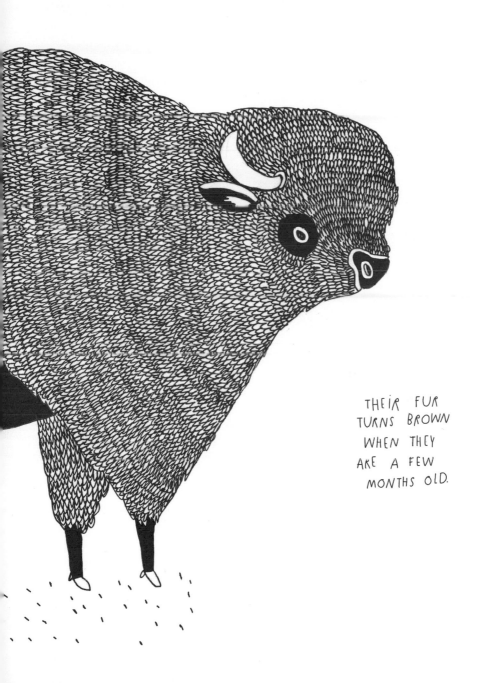

THEIR FUR
TURNS BROWN
WHEN THEY
ARE A FEW
MONTHS OLD.

81.

HEN-LIKE
BIRDS WHO BUILD
THEIR NESTS ON
THE GROUND
IN VERY DRY
AREAS

SANDGROUSE DADS

BRING WATER TO THEIR
CHICKS BY FLYING TO
WATER, TAKING A DIP,
AND FLYING BACK.

THEY HAVE SPECIAL
HAIRLIKE FEATHERS ON
THEIR BELLIES THAT ARE
ADAPTED FOR
SUCKING UP WATER
THAT THE BABIES
CAN DRINK.

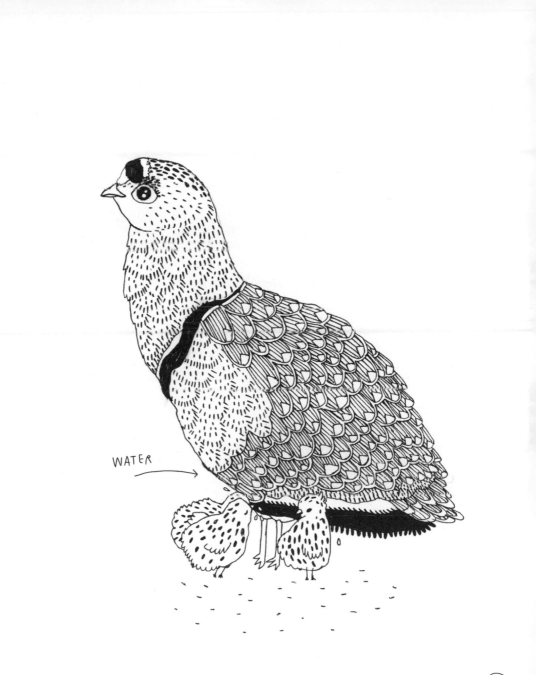

WATER

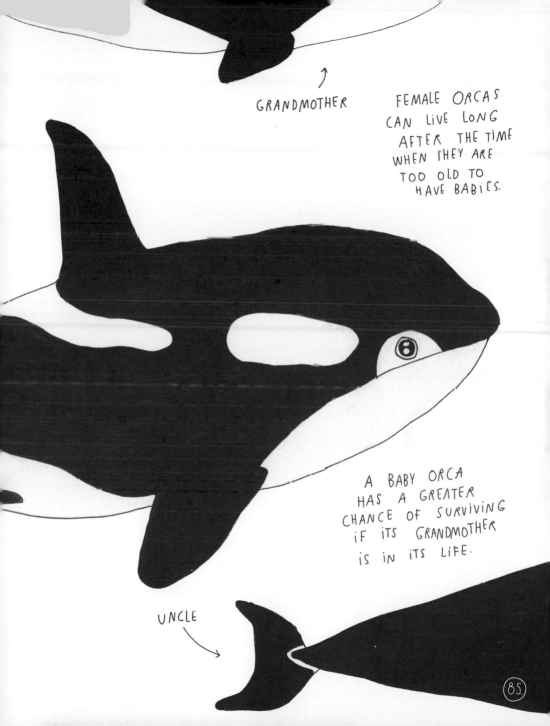

GRANDMOTHER

FEMALE ORCAS CAN LIVE LONG AFTER THE TIME WHEN THEY ARE TOO OLD TO HAVE BABIES.

A BABY ORCA HAS A GREATER CHANCE OF SURVIVING IF ITS GRANDMOTHER IS IN ITS LIFE.

UNCLE

BARNACLE GEESE

BUILD THEIR NESTS ON
HIGH CLIFFS TO PROTECT
THEIR EGGS
FROM PREDATORS.

BEFORE THE CHICKS
LEARN TO FLY, THEY
HAVE TO THROW THEMSELVES
OUT TO GET DOWN
TO THEIR PARENTS.

1,300 FEET
(400 METERS)
DOWN
↓

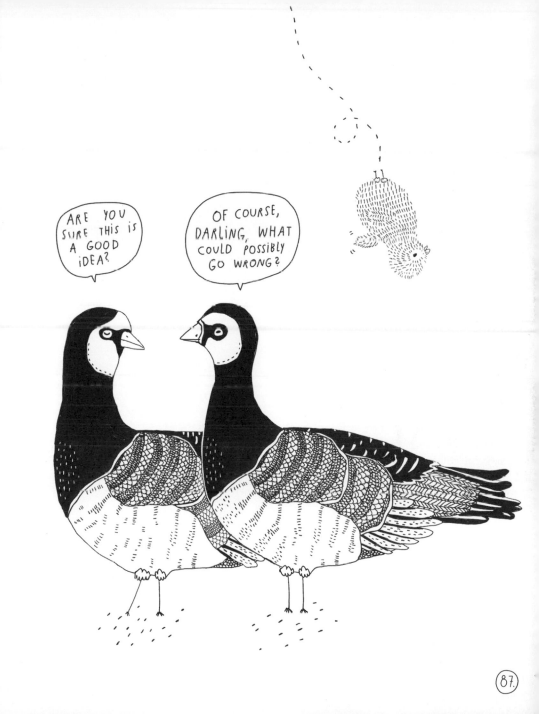

BECAUSE MALE
BROWN BEARS
WILL TRY TO KILL ANY
CUBS THAT ARE NOT THEIR OWN,
FEMALES OFTEN MATE WITH
SEVERAL MALES SO EACH
OF THEM WILL THINK HE
IS THE FATHER
OF THE CUBS.

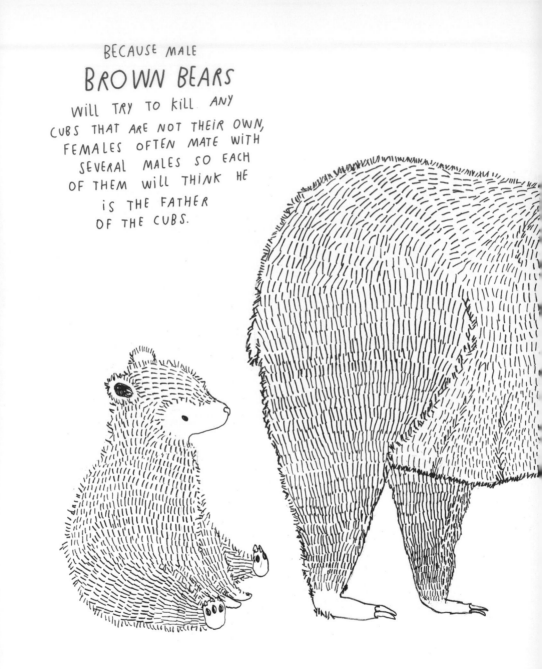

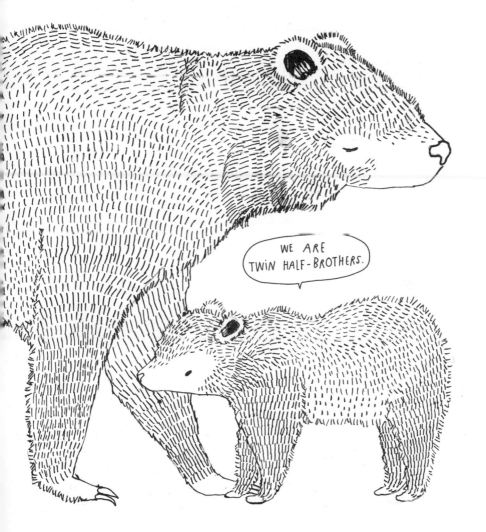

THE MILK OF
GRAY SEALS
IS THICKER THAN CREAM,
SO SEAL CUBS GAIN
4 POUNDS (2 KILOS)
<u>PER DAY</u>
WHEN THEY NURSE!

AFTER THREE WEEKS TOGETHER
WITH HER CUB, A SEAL MOTHER
MATES AGAIN, THEN SHE LEAVES HER
BABY TO CARE FOR ITSELF.

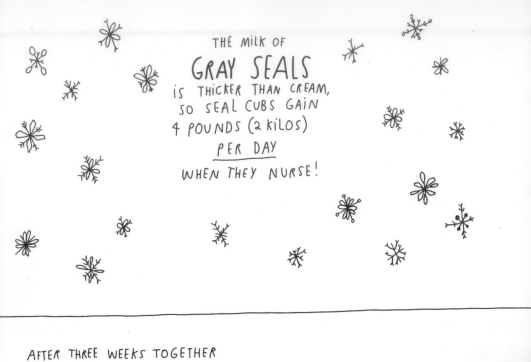

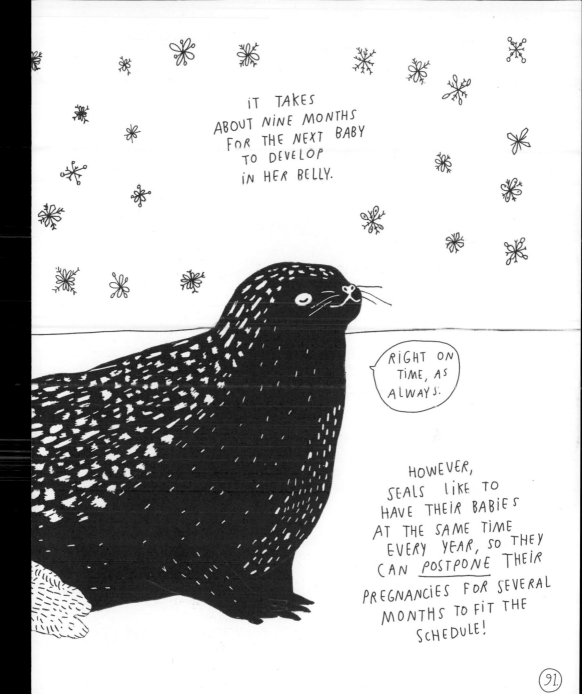

IT TAKES ABOUT NINE MONTHS FOR THE NEXT BABY TO DEVELOP IN HER BELLY.

RIGHT ON TIME, AS ALWAYS.

HOWEVER, SEALS LIKE TO HAVE THEIR BABIES AT THE SAME TIME EVERY YEAR, SO THEY CAN POSTPONE THEIR PREGNANCIES FOR SEVERAL MONTHS TO FIT THE SCHEDULE!

ALL THE OTHER ADULTS
ARE HER WORKERS.

WORKERS THAT EAT
THE QUEEN'S POOP SHOW
MORE WILLINGNESS TO
TAKE CARE OF
HER BABIES!

ABOUT A QUARTER OF ALL

MOURNING SWAN

COUPLES ARE HOMOSEXUAL!

TO GET BABIES
OF THEIR OWN,
MALE COUPLES
TEMPORARILY TEAM
UP WITH A FEMALE
AND THEN BRING
UP THE CHICKS
WITHOUT HER.

FATHER I

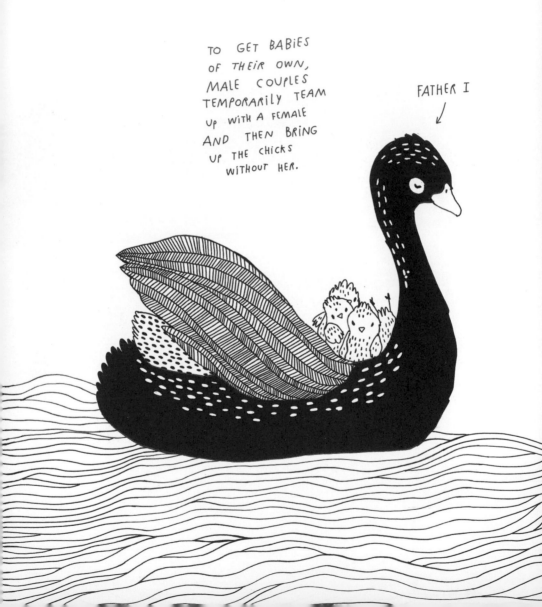

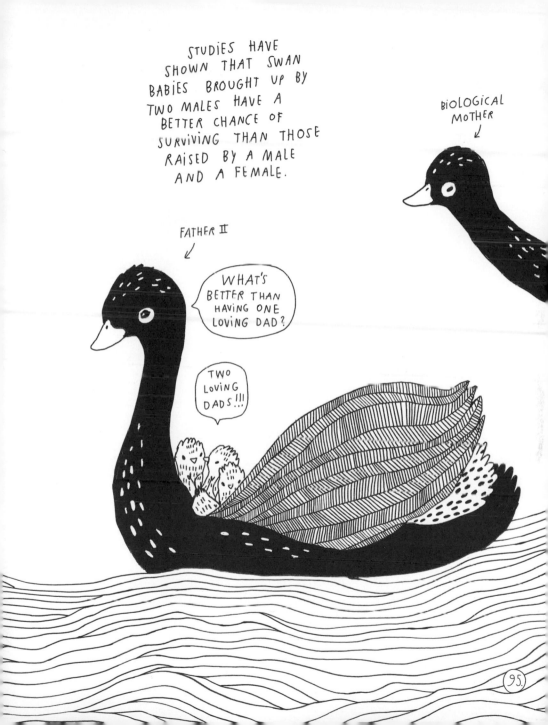

TENRECS

ARE HEDGEHOG-LIKE
ANIMALS FROM MADAGASCAR
THAT CAN HAVE 32
BABIES IN ONE LITTER.

TO FEED ALL
THOSE BABIES,
FEMALE TENRECS
CAN HAVE UP TO
29 NIPPLES!

ONE
FOR EACH
BABY...ish.

TENRECS HAVE POOR EYESIGHT,
SO TO KEEP TRACK OF EACH OTHER
THEY SOMETIMES DRAG THEIR
BOTTOMS ON THE GROUND TO
CREATE A SCENT TRAIL.

32 BABIES IS THIS MANY:

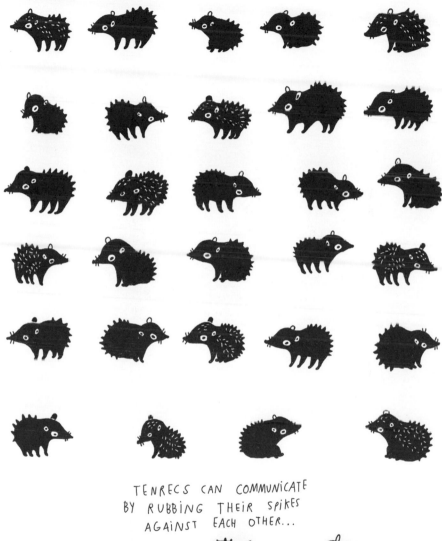

TENRECS CAN COMMUNICATE
BY RUBBING THEIR SPIKES
AGAINST EACH OTHER...

...TO MAKE DIFFERENT SOUNDS.

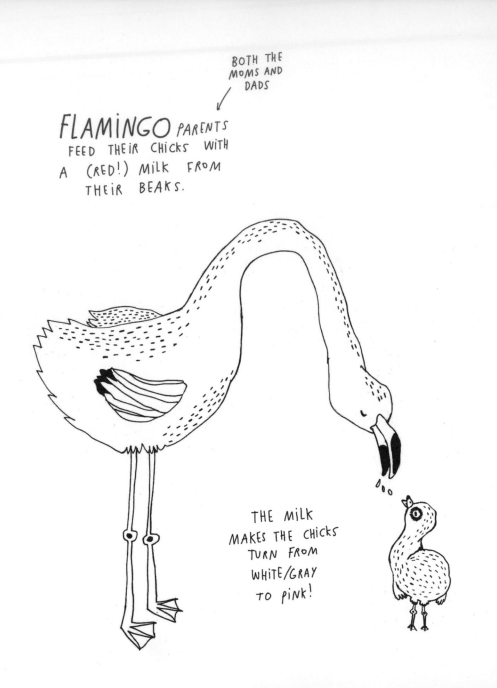

BOTH THE
MOMS AND
DADS

FLAMINGO PARENTS
FEED THEIR CHICKS WITH
A (RED!) MILK FROM
THEIR BEAKS.

THE MILK
MAKES THE CHICKS
TURN FROM
WHITE/GRAY
TO PINK!

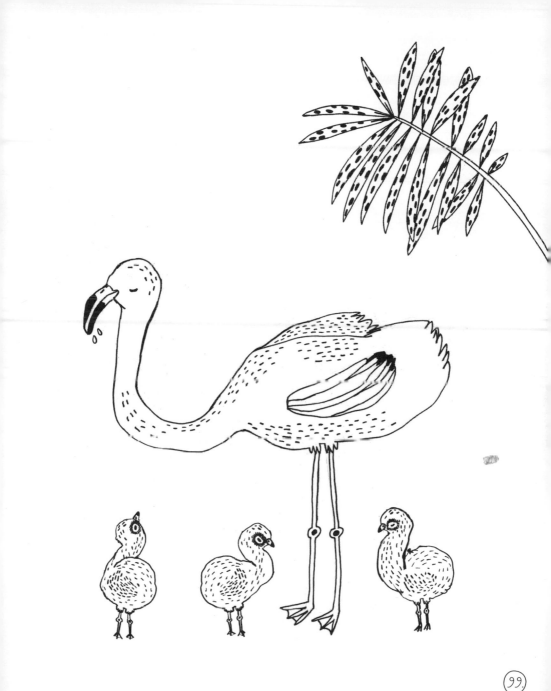

THE FEMALE
GIANT PACIFIC OCTOPUS
LAYS EGGS JUST ONCE IN HER LIFE.

SHE FINDS A CAVE AND HANGS HER
EGGS FROM THE CEILING.

THEN SHE STAYS WITH THE EGGS WITHOUT
FOR MONTHS (SOMETIMES YEARS). ← EATING

DURING THIS TIME, SHE CONSTANTLY WAVES
HER ARMS TO MAKE SURE THE EGGS HAVE
FRESH WATER.

THE BABIES
LOOK JUST LIKE
MINIATURE VERSIONS
OF THEIR PARENTS.
THEY EVEN HAVE
SUCTION CUPS
ON THEIR ARMS.

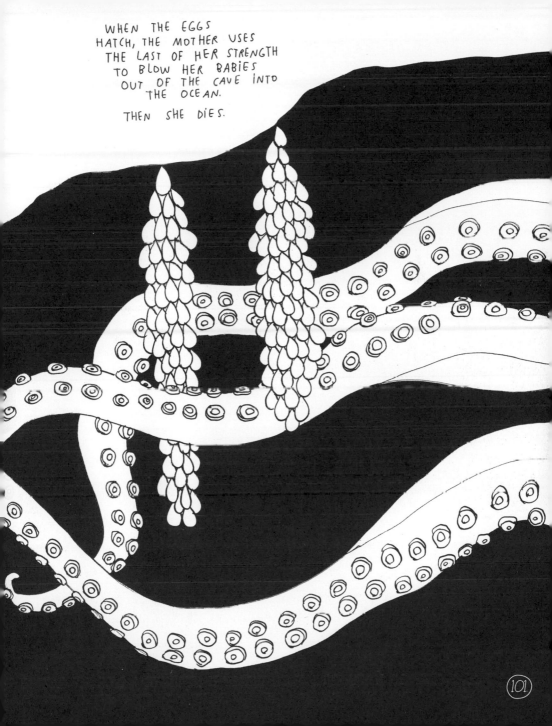

WHEN THE EGGS
HATCH, THE MOTHER USES
THE LAST OF HER STRENGTH
TO BLOW HER BABIES
OUT OF THE CAVE INTO
THE OCEAN.

THEN SHE DIES.

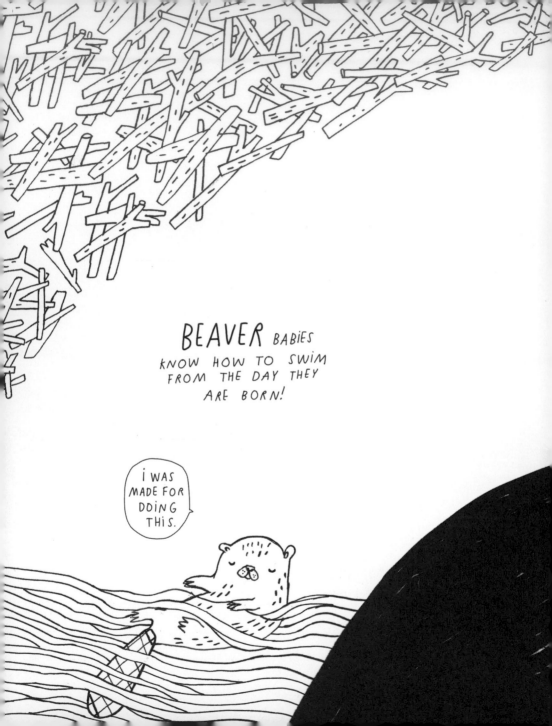

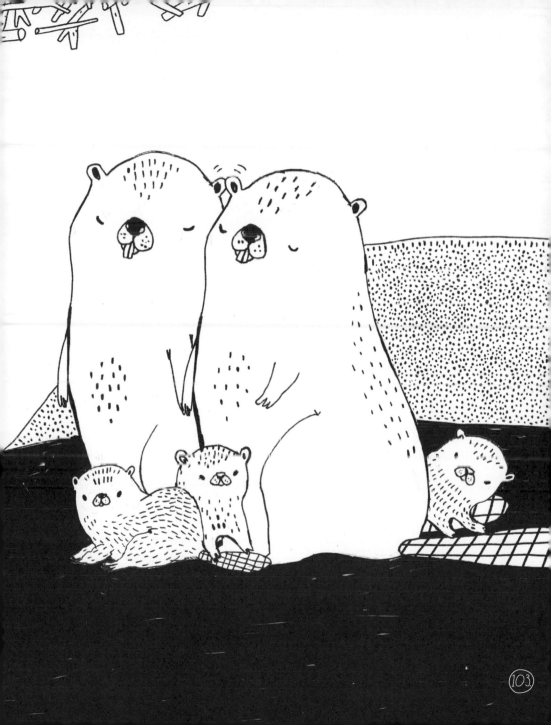

PANGOLINS
CARRY THEIR BABIES
ON THEIR TAILS!

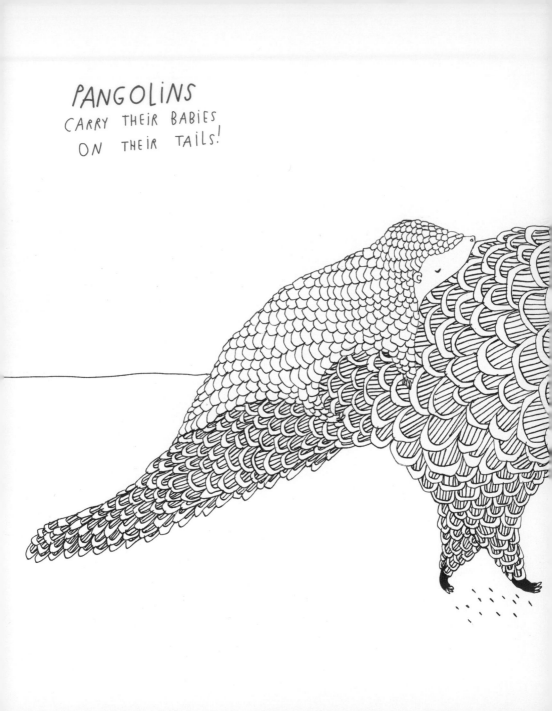

AND THEY PROTECT
THE BABIES AGAINST
DANGER BY CURLING
UP AROUND THEM
LIKE A BALL!

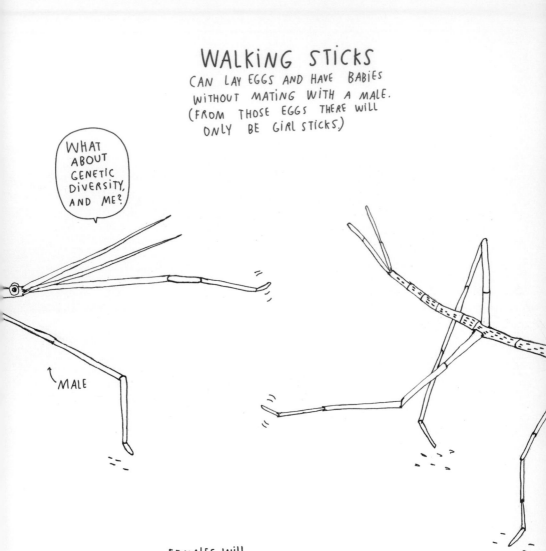

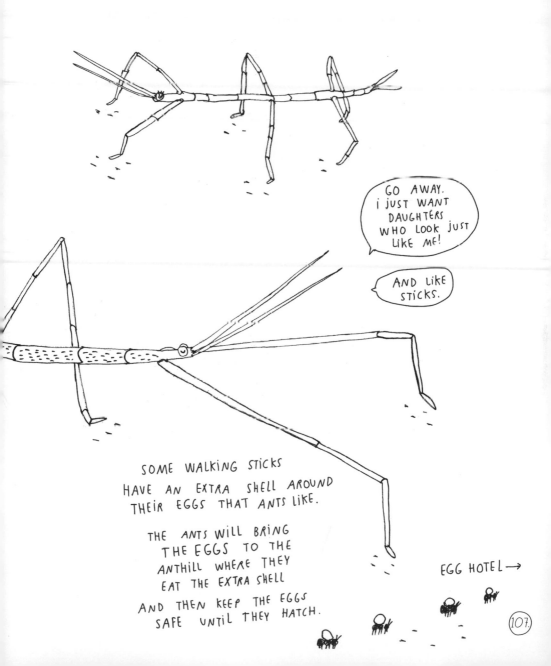

GO AWAY.
i JUST WANT
DAUGHTERS
WHO LOOK JUST
LIKE ME!

AND LIKE
STICKS.

SOME WALKING STICKS
HAVE AN EXTRA SHELL AROUND
THEIR EGGS THAT ANTS LIKE.

THE ANTS WILL BRING
THE EGGS TO THE
ANTHILL WHERE THEY
EAT THE EXTRA SHELL
AND THEN KEEP THE EGGS
SAFE UNTIL THEY HATCH.

EGG HOTEL →

GIRAFFES

GIVE BIRTH STANDING UP.
SO GIRAFFE CALVES START
THEIR LIVES BY FALLING
7 FEET (2 METERS)
TO THE GROUND.

THEY SEEM TO HANDLE
IT PRETTY WELL BECAUSE
WITHIN HALF AN HOUR
THEY NEED TO STAND
ON THEIR LEGS AND
WALK WITH THE GROUP.

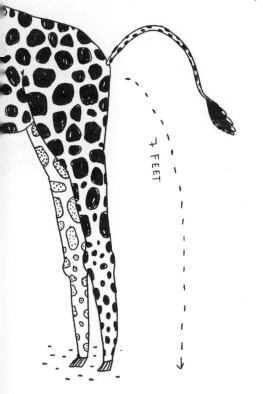

7 FEET

WHEN A BABY
GIRAFFE NEEDS
TO REST, IT PUTS ITS
HEAD ON ITS BUTT!

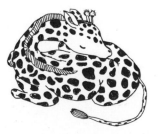

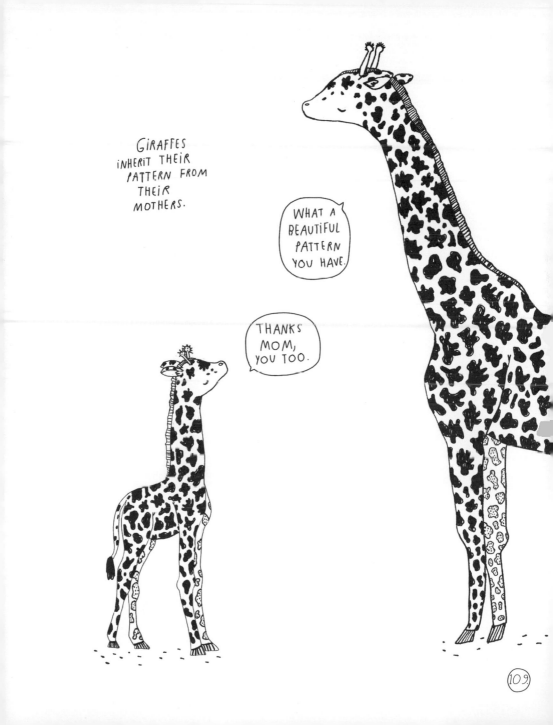

MAJA SÄFSTRÖM
IS A STOCKHOLM-BASED
ILLUSTRATOR & AUTHOR WHO HAS GAINED
INTERNATIONAL RECOGNITION FOR HER
QUIRKY ANIMAL DRAWINGS & BOOKS.
FOR MORE OF HER WORK, VISIT
WWW.MAJASBOK.COM

MAJA
SÄFSTRÖM →
(AND HER CUBS)

WILLE
↓

ESTRID
↓